DesignOriginals

Creative Coloring

A second cup of

Inspirations

Valentina Harper

DESIGN ORIGINALS
an Imprint of Fox Chapel Publishing
www.d-originals.com

Basic Color Ideas

In order to truly enjoy this coloring book, you must remember that there is no wrong way—or right way—to paint or use color. My drawings are created precisely so that you can enjoy the process no matter what method you choose to use to color them!

The most important thing to keep in mind is that each illustration was made to be enjoyed as you are coloring, to give you a period of relaxation and fun at the same time. Each picture is filled with details and forms that you can choose to color in many different ways. I value each person's individual creative process, so I want you to play and have fun with all of your favorite color combinations.

As you color, you can look at each illustration as a whole, or you can color each part as a separate piece that, when brought together, makes the image complete. That is why it is up to you to choose your own process, take your time, and, above all, enjoy your own way of doing things.

To the right are a few examples of ways that you can color each drawing.

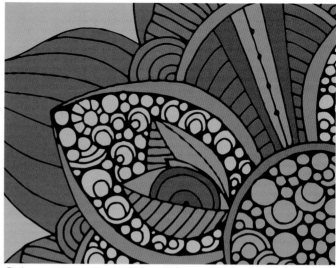

Color each section of the drawing (every general area, not every tiny shape) in one single color.

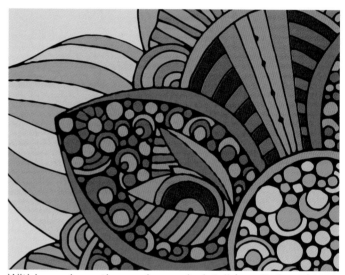

Within each section, color each detail (small shape) in alternating colors.

Leave some areas white to add a sense of space and lightness to the illustration.

Basic Color Tips

As an artist, I love to mix techniques, colors, and different mediums when it comes time to add color to my works of art. And when it comes to colors, the brighter the better! I feel that with color, illustrations take on a life of their own.

Remember: when it comes to painting and coloring, there are no rules. The most fun part is to play with color, relax, and enjoy the process and the beautiful finished result.

Feel free to mix and match colors and tones. Work your way from primary colors to secondary colors to tertiary colors, combining different tones to create all kinds of different effects. If you aren't familiar with color theory, below is a quick, easy guide to the basic colors and combinations you will be able to create.

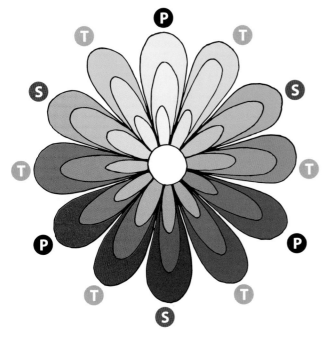

P Primary colors: These are the colors that cannot be obtained by mixing any other colors; they are yellow, blue, and red.

S Secondary colors: These colors are obtained by mixing two primary colors in equal parts; they are green, purple, and orange.

T Tertiary colors: These colors are obtained by mixing one primary color and one secondary color.

Don't be afraid of mixing colors and creating your own palettes. Play with colors—the possibilities are endless!

Color Inspiration

On the following pages, you'll see fully colored samples of my illustrations in this book, as interpreted by an array of talented artists. I was delighted to invite other artists to color my work, and they used many different mediums to do so, all listed below each image. Take a look at how these artists decided to color the designs, and find some inspiration for your own coloring! After the colored samples, the 32 delightful drawings just waiting for your color begin. Remember the tips I showed you earlier, think of the color inspiration you've seen, and choose your favorite medium to get started, whether it's pencil, marker, watercolor, or something else. Your time to color begins now, and only ends when you run out of pages! Have fun!

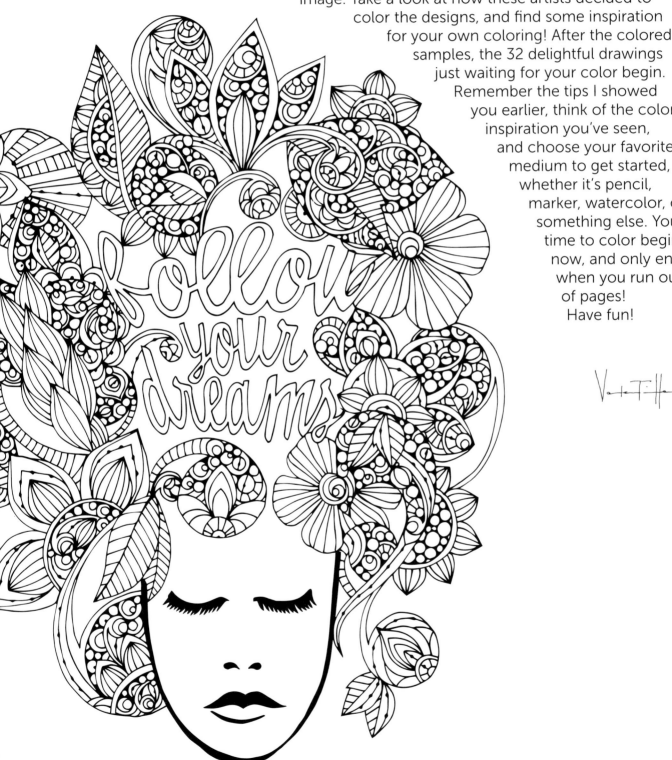

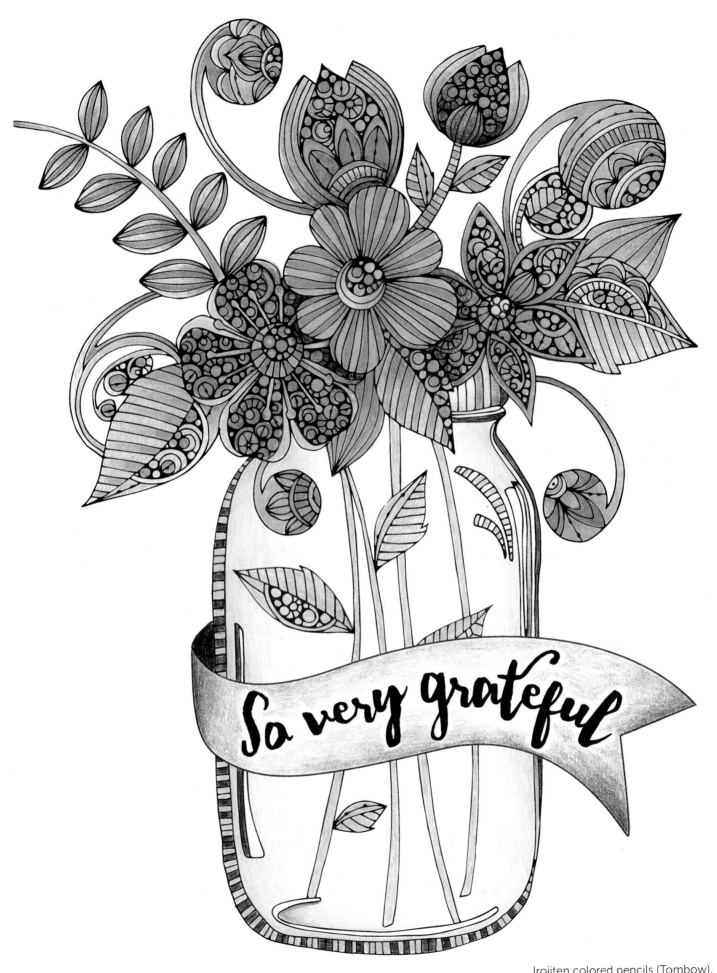

So very grateful

Irojiten colored pencils (Tombow).
Color by Marie Browning.

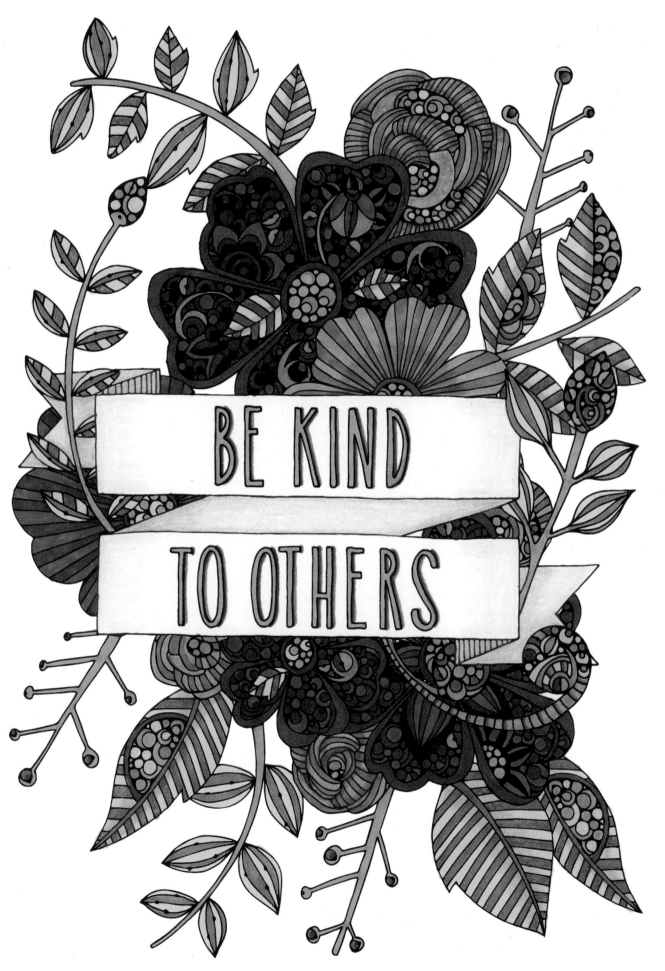

BE KIND
TO OTHERS

Colored pencils (Prismacolor), markers (Sharpie, Bic).
Color by Darla Tjelmeland.

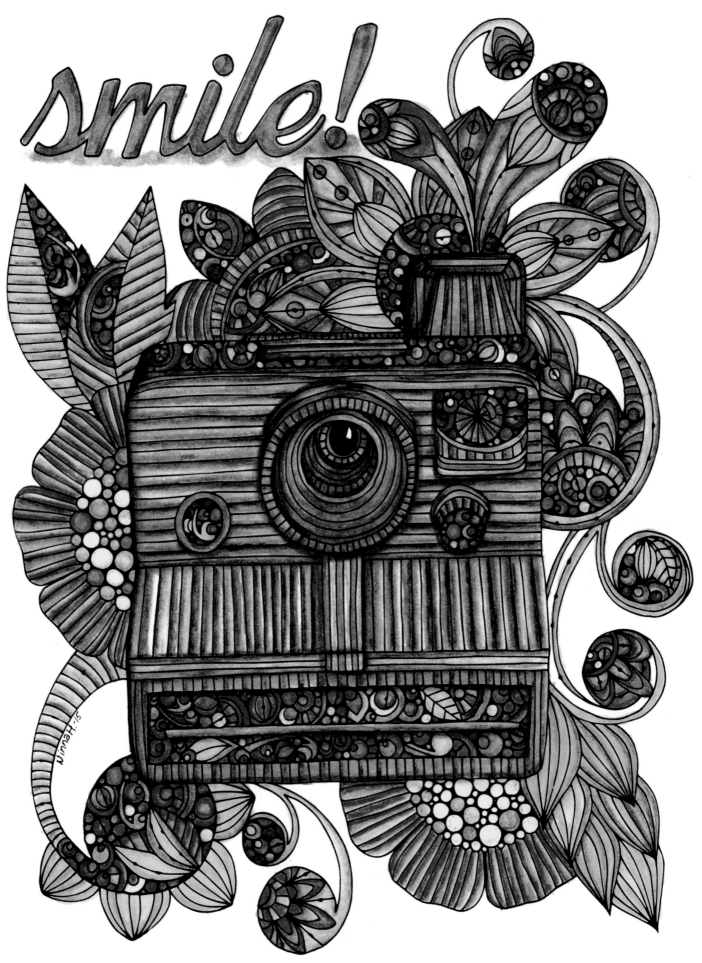

smile!

Colored pencils (Spectrum Noir).
Color by Ninna Hellman.

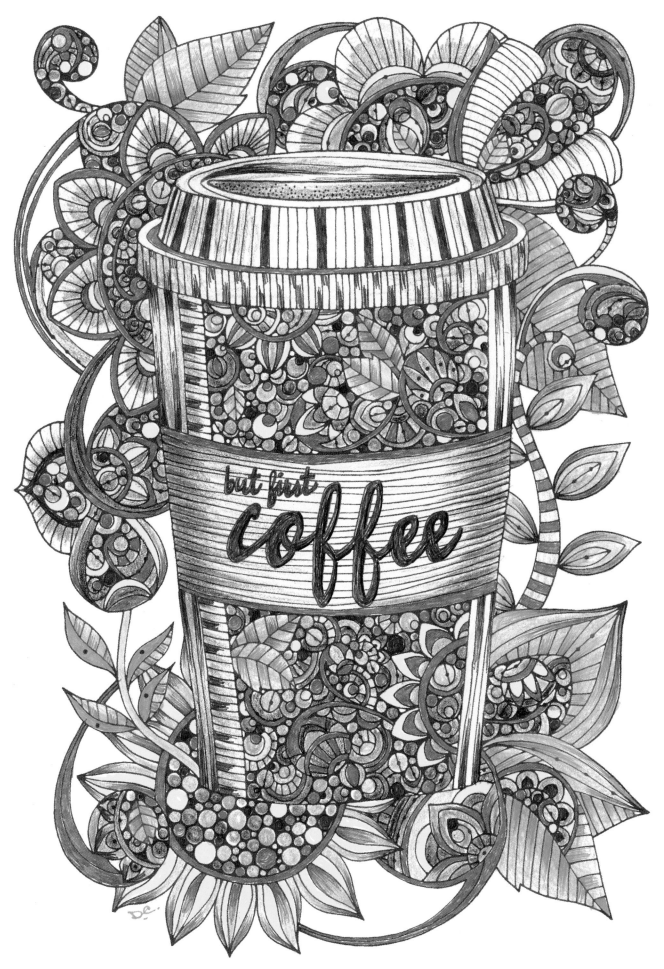

Fine point pens (Sharpie and Sakura Micron), colored pencils (Prismacolor). Color by Dawn Collins.

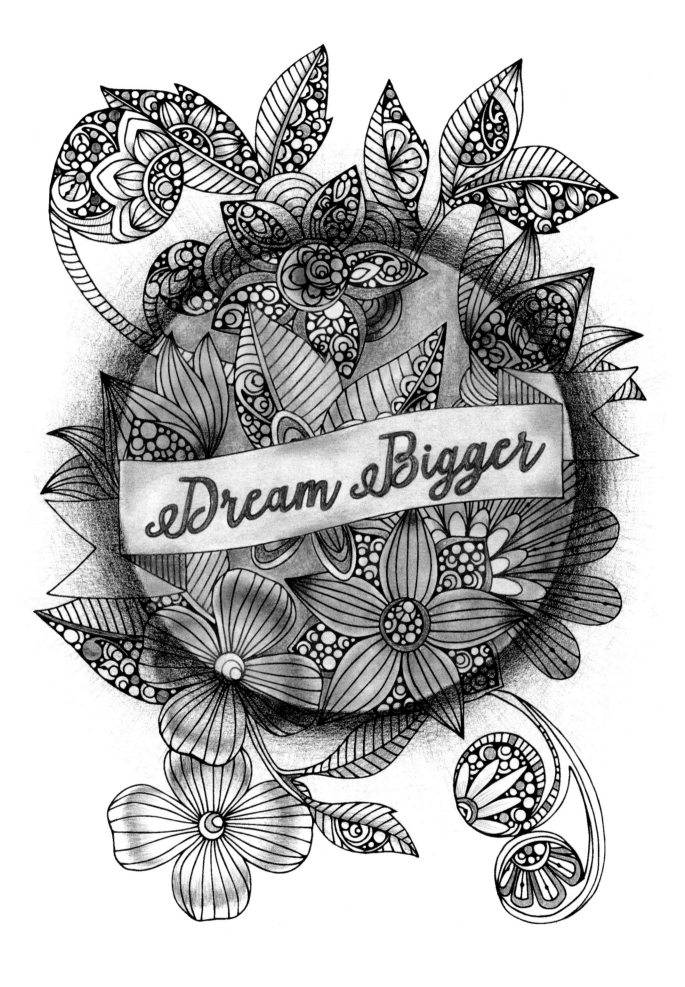

Pastel pencils (PanPastel), chalk, graphite pencils (HB to 6B).
Color by Helga Cuypers.

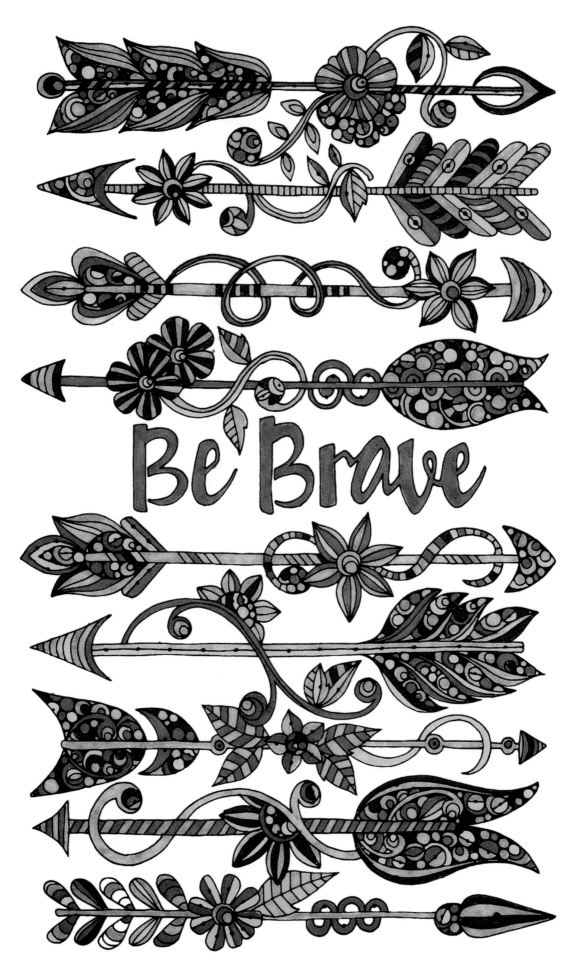

Be Brave

Markers (Sharpie). Color by Erica Avedikian.

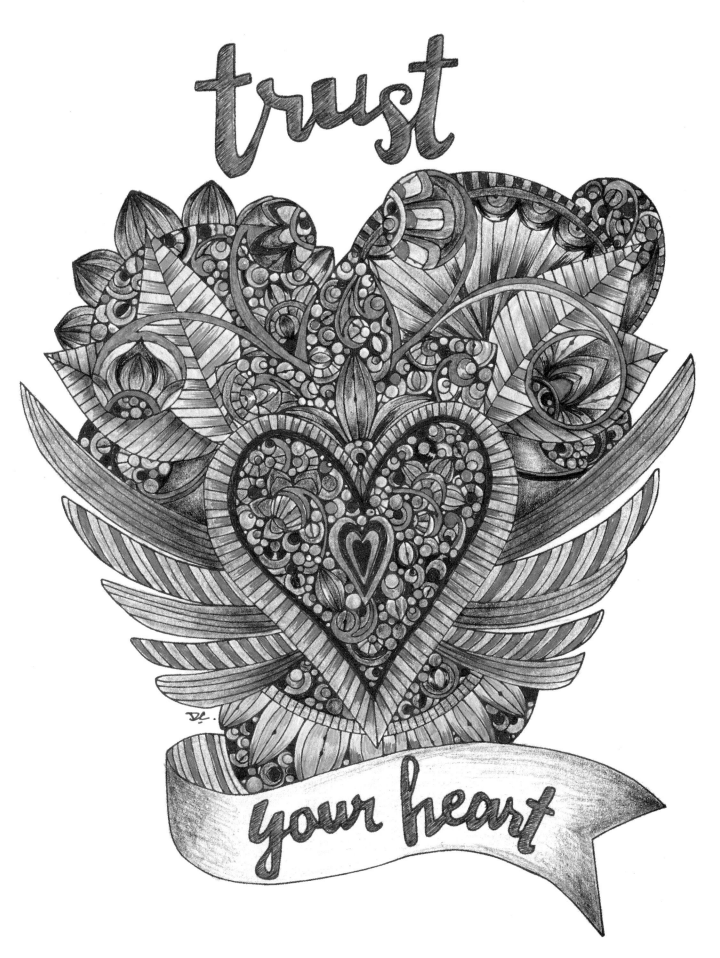

Fine point pens (Sharpie and Sakura Micron), colored pencils (Prismacolor). Color by Dawn Collins.

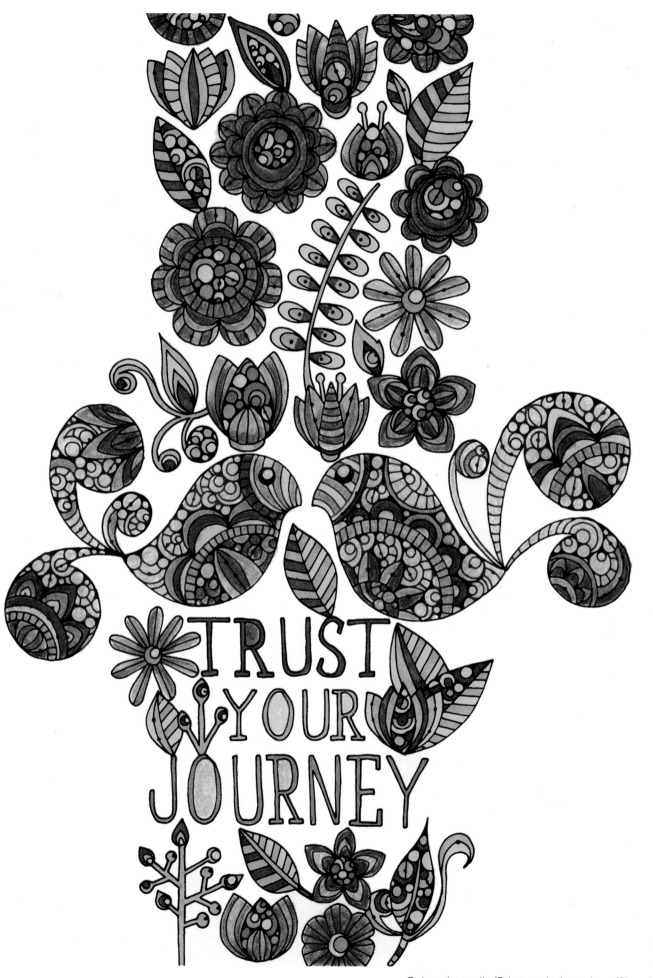

TRUST YOUR JOURNEY

Colored pencils (Prismacolor), markers (Sharpie).
Color by Darla Tjelmeland.

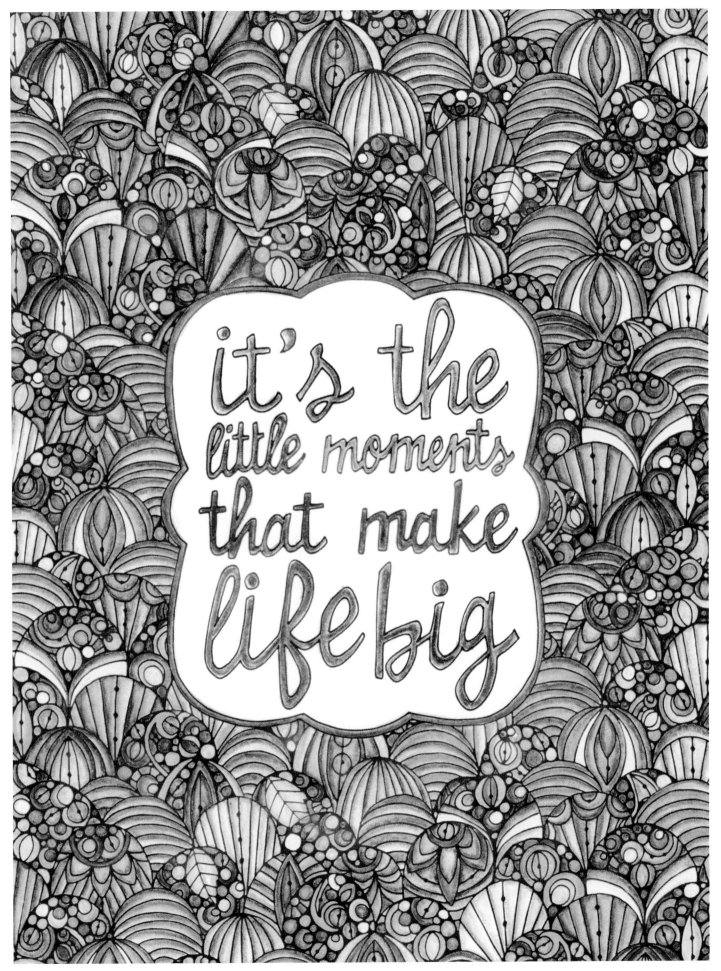

it's the little moments that make life big

Colored pencils (Spectrum Noir).
Color by Ninna Hellman.

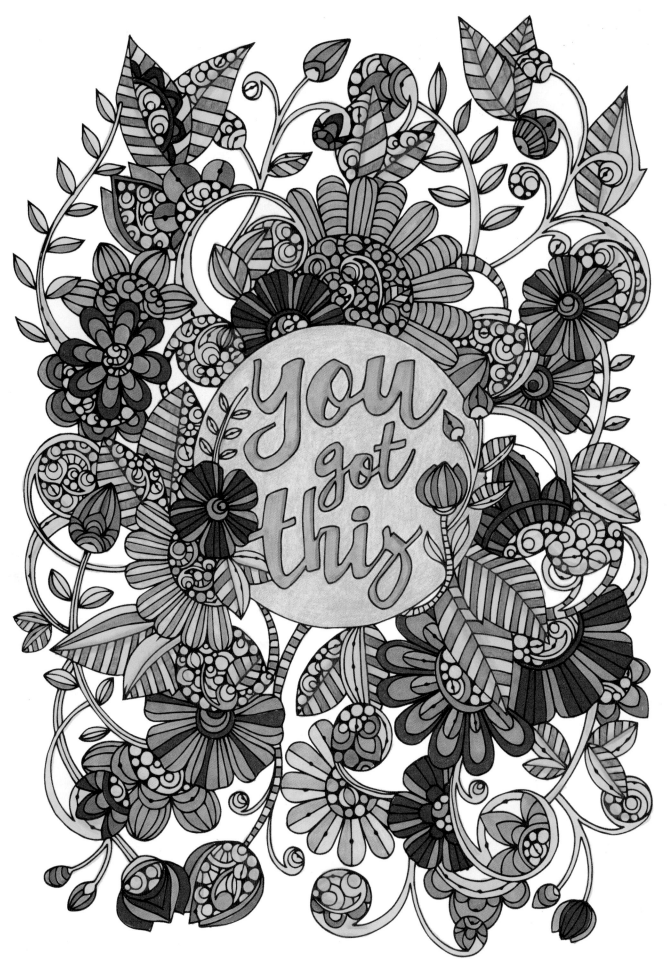

Colored pencils (Prismacolor), markers (Sharpie, Bic).
Color by Darla Tjelmeland.

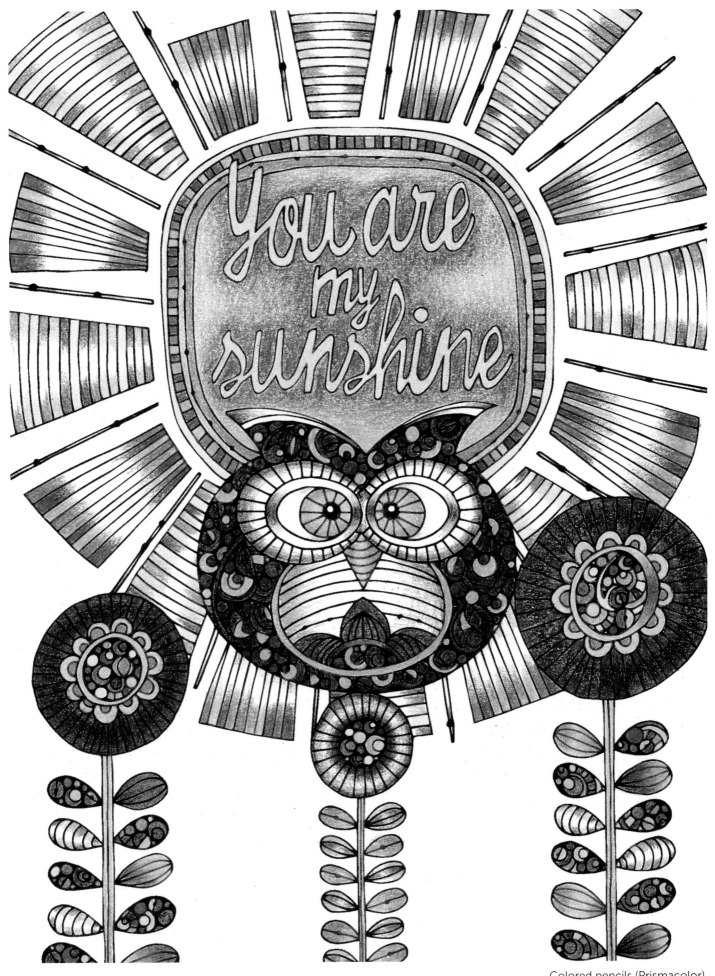

You are my sunshine

Colored pencils (Prismacolor).
Color by Helga Cuypers.

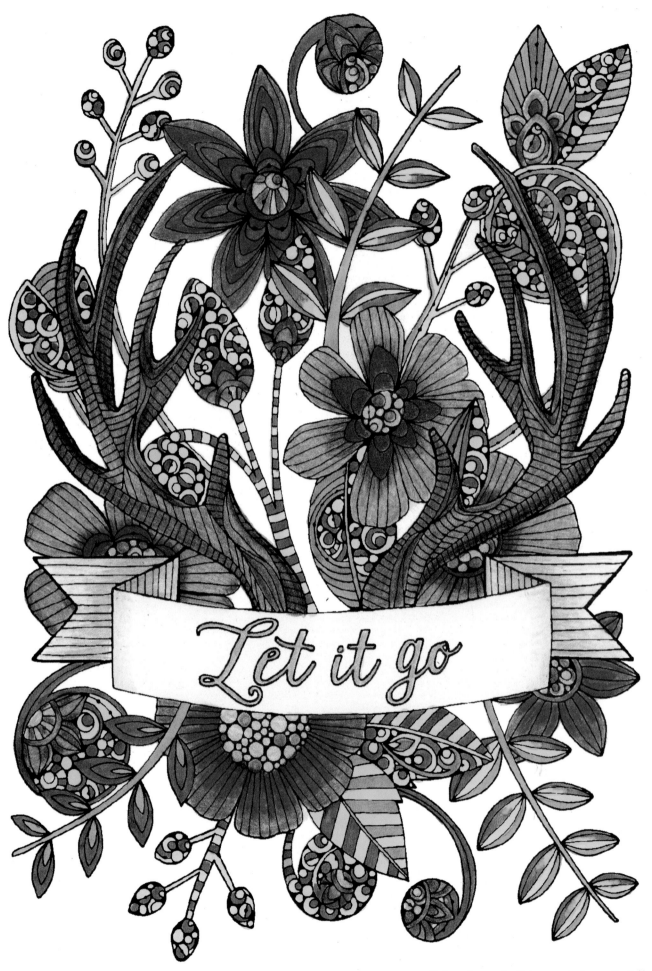

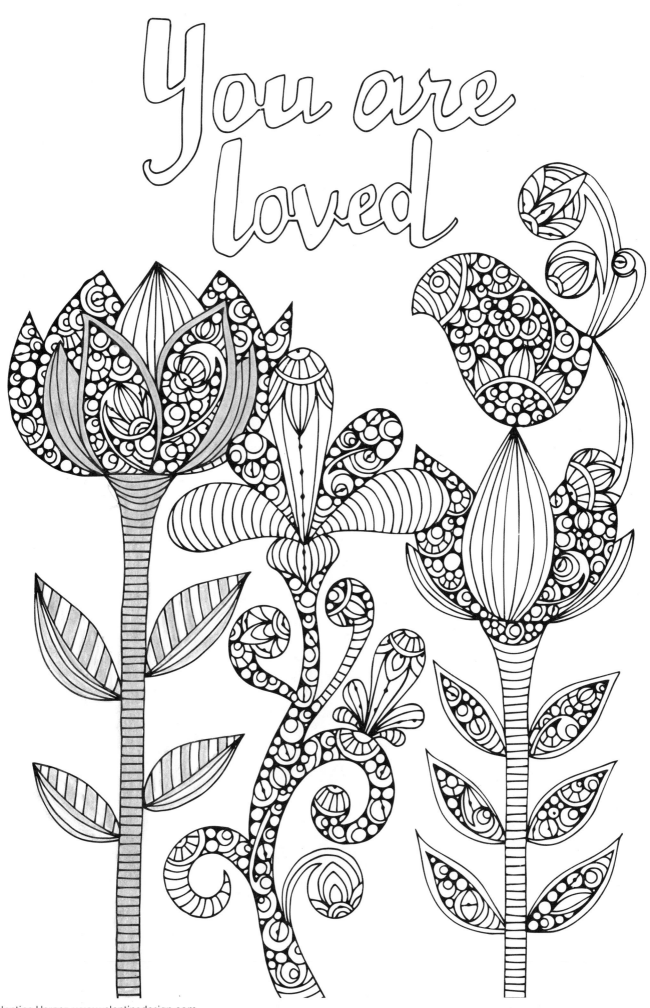

Pause and remember—love is available to you
the moment you are available to love.

—Jenni Young

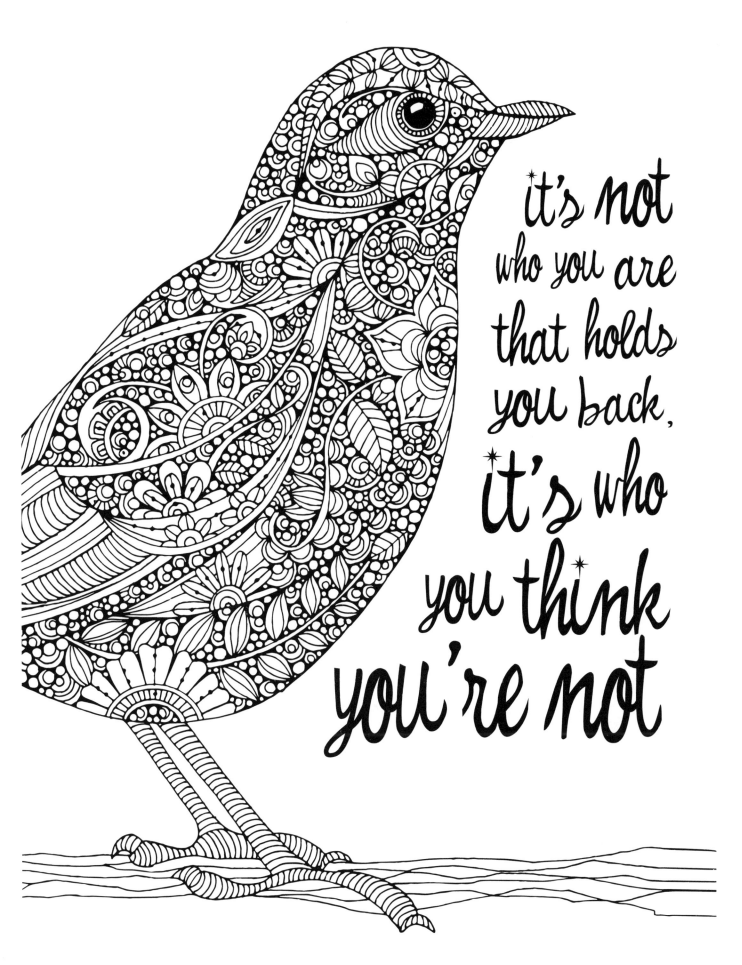

it's not who you are that holds you back, it's who you think you're not

The secret of life isn't what happens to you,
but what you do with what happens to you.

—Norman Vincent Peale

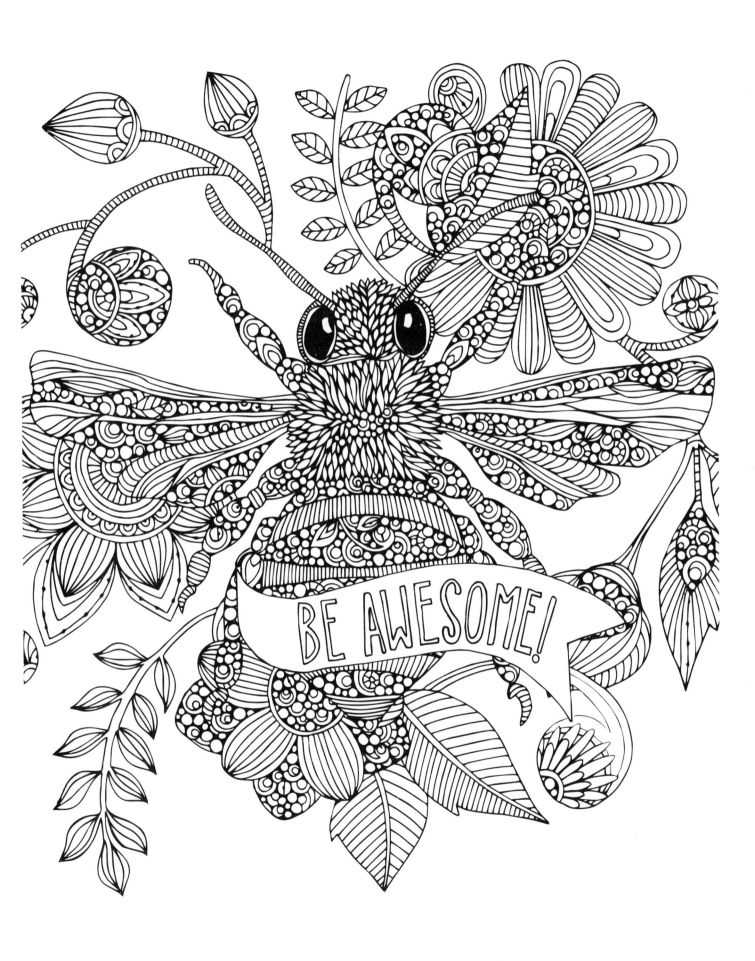

BE AWESOME!

Be who you were created to be
and you will set the world on fire.

—St. Catherine of Sienna

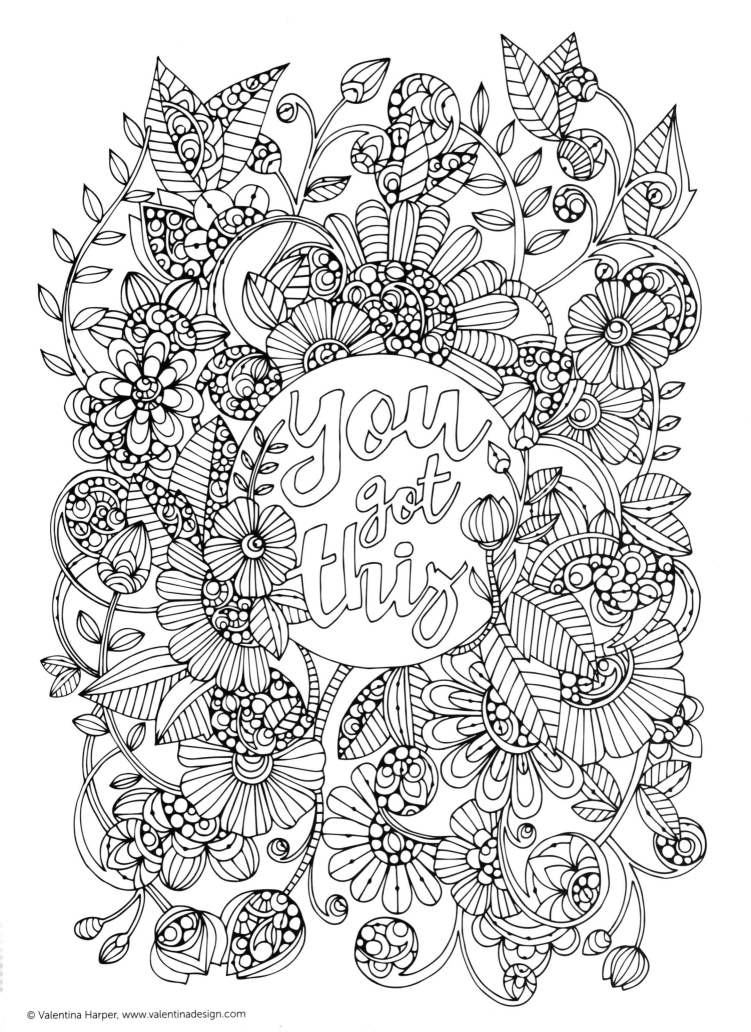

She turned her can'ts into cans
and her dreams into plans.

—Kobi Yamada

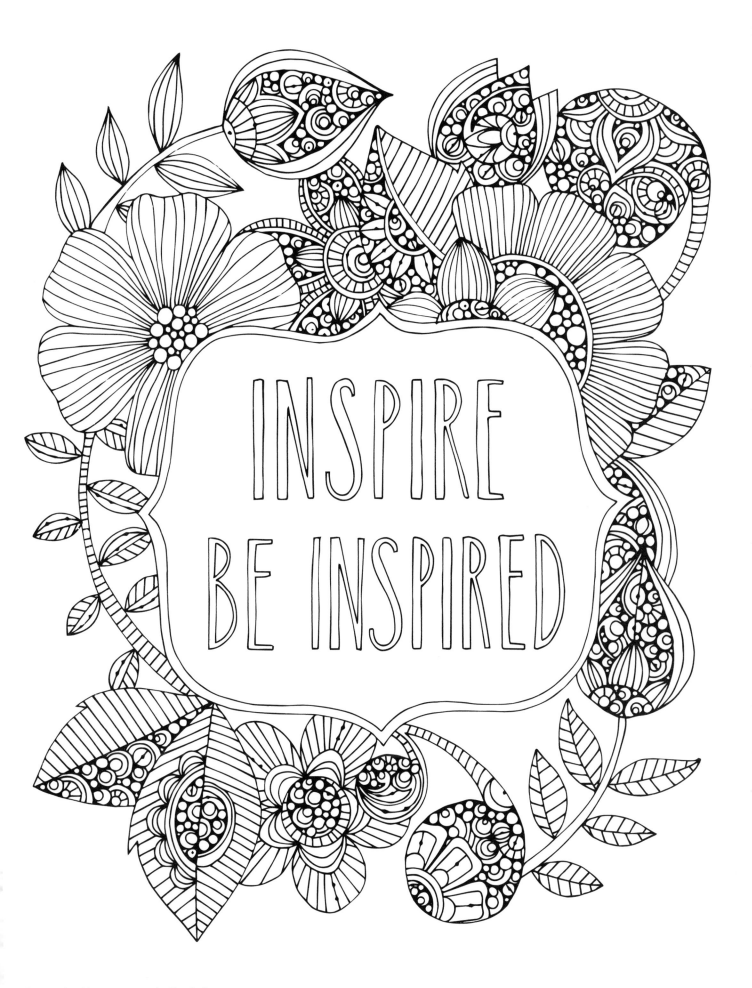

The greatest good we can do for others
is not just to share our riches with them,
but to reveal theirs.

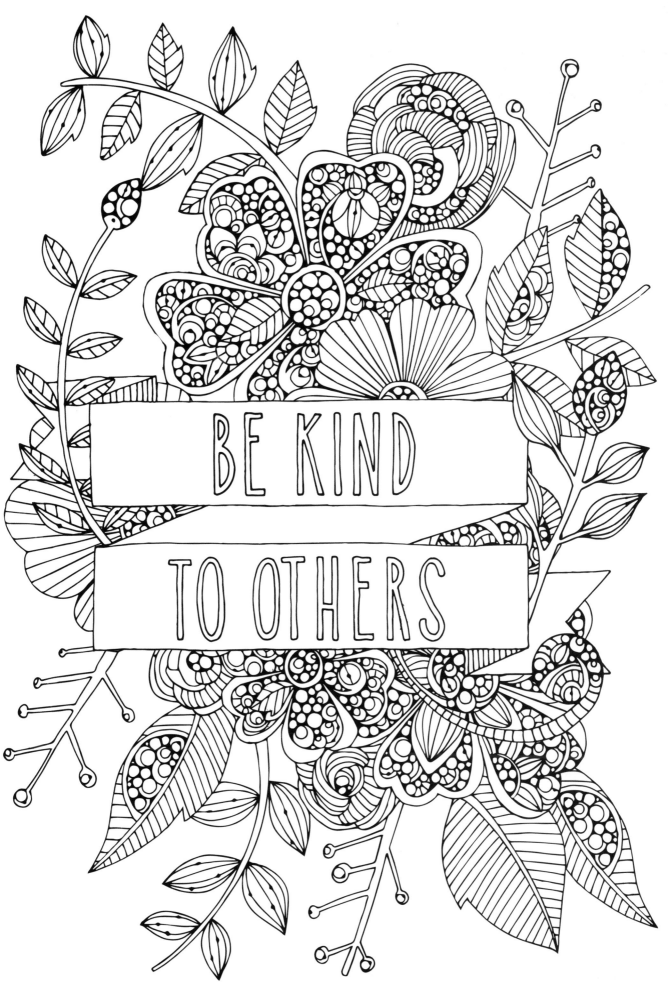

My religion is very simple.
My religion is kindness.

—Dalai Lama

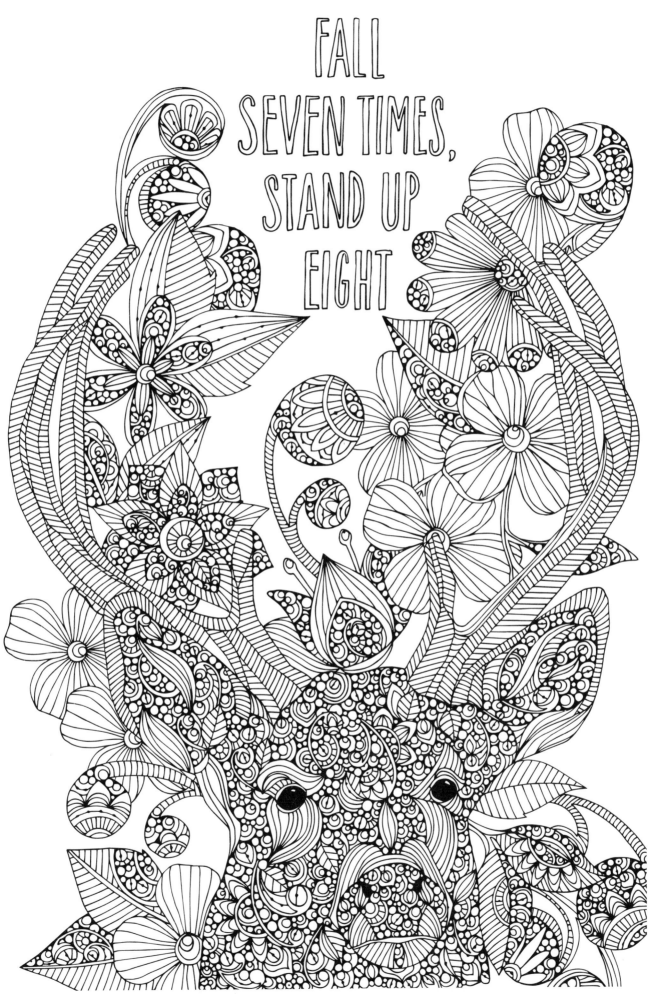

FALL
SEVEN TIMES,
STAND UP
EIGHT

One of the secrets of life is to make
stepping stones out of stumbling blocks.

—Jack Penn

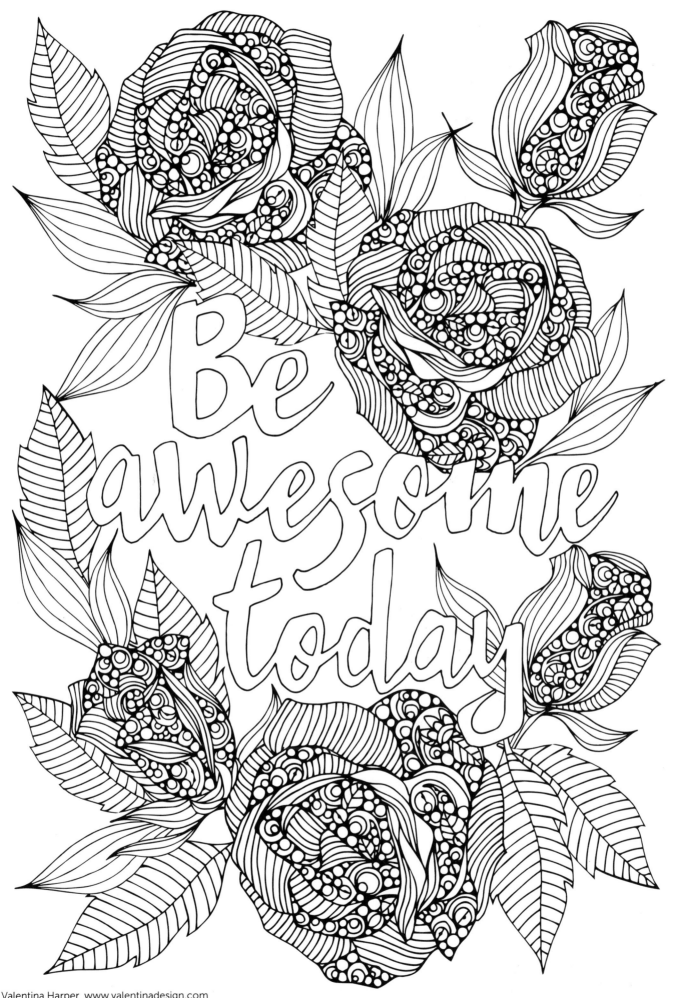

If you want to be average, do what others do.
If you want to be awesome,
do what no one does.

—Alexander Den Heijer

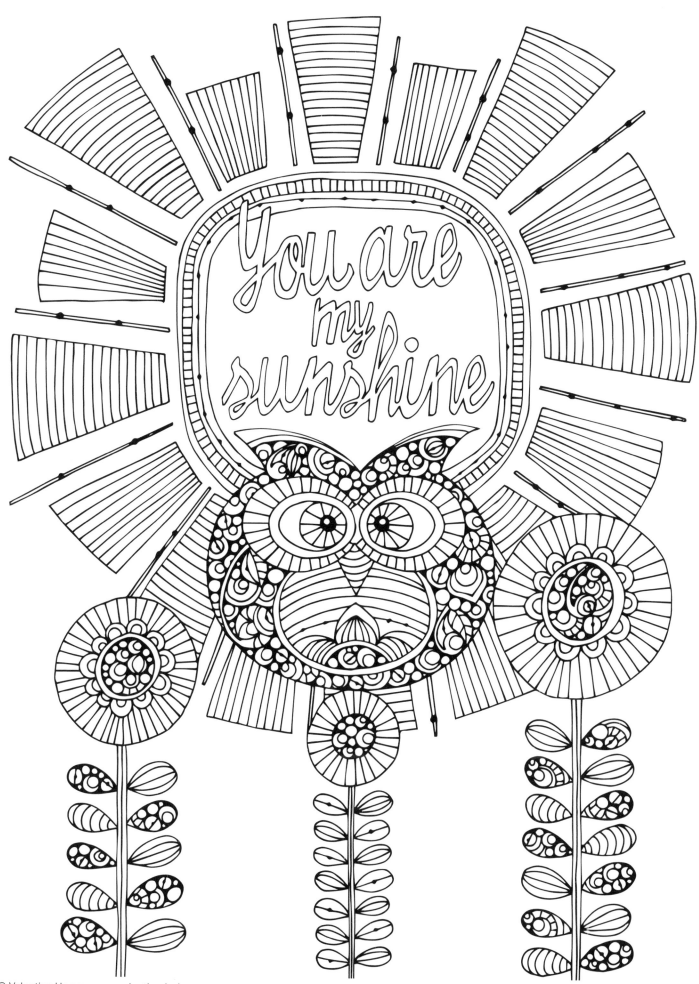

I carry your heart (I carry it in my heart).

—E. E. Cummings

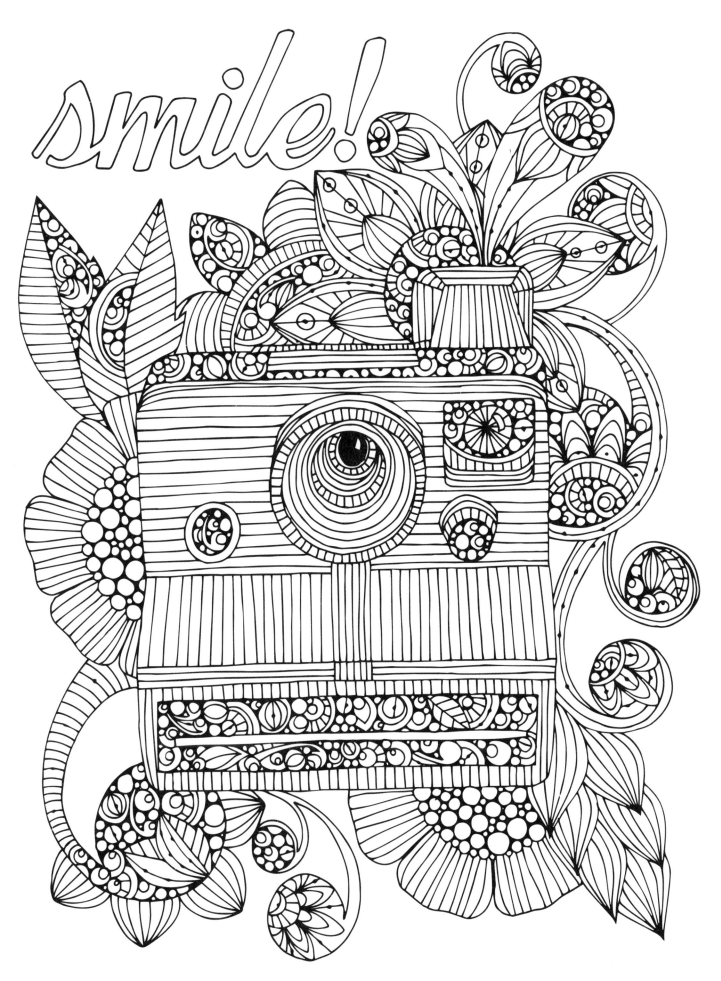

If you smile when you are alone,
then you really mean it.

—Andy Rooney

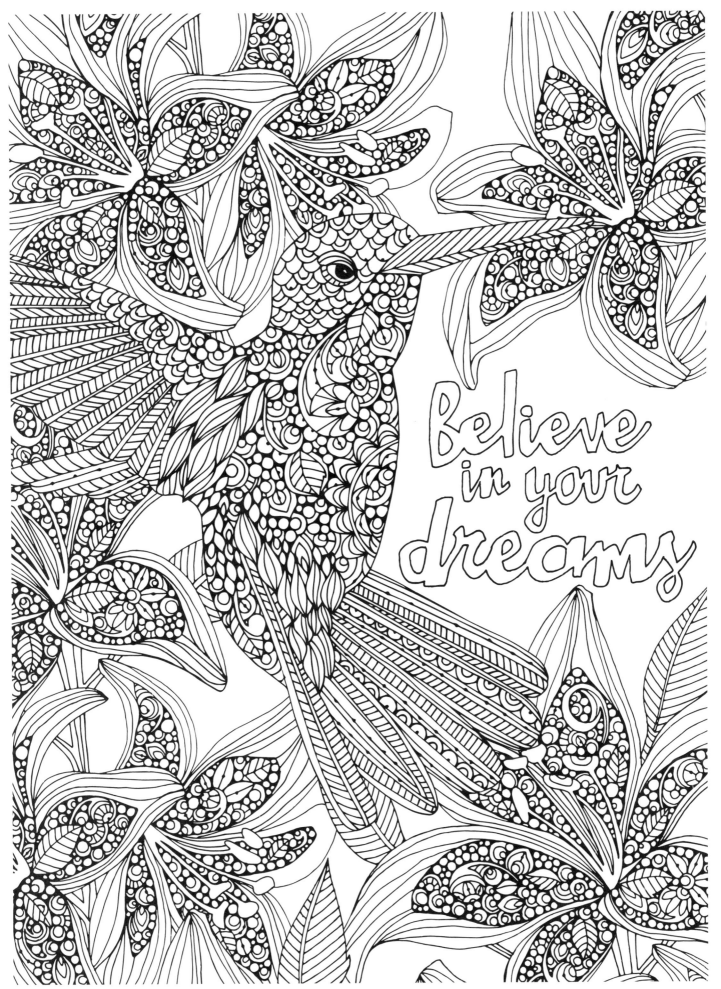

believe in your dreams

Believe in your heart
you were meant to live a life full of
passion, purpose, magic, and miracles.

—Roy Bennett

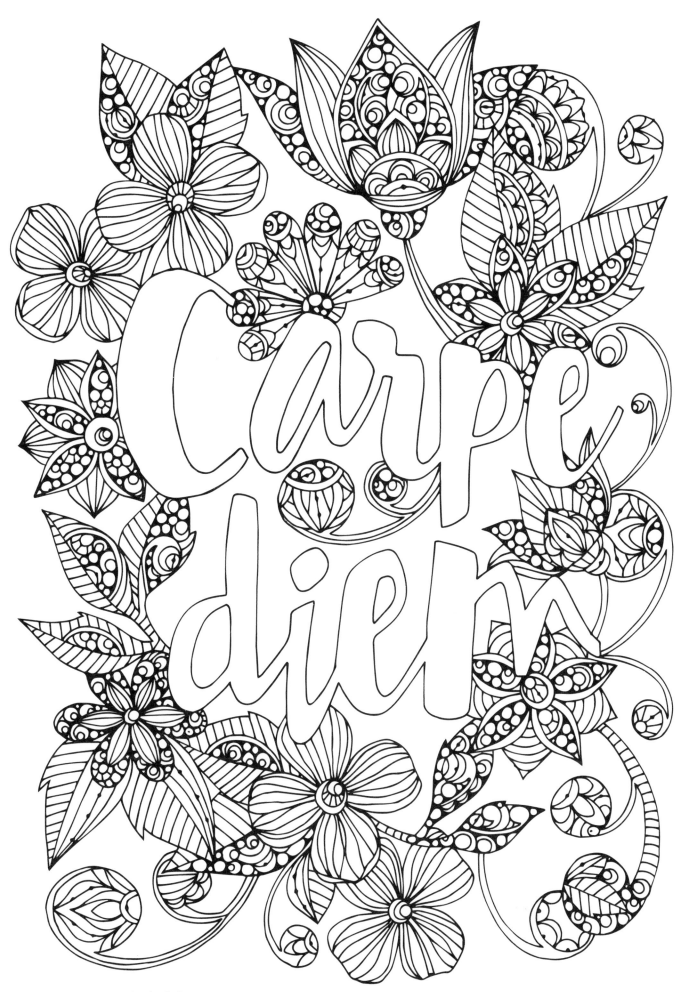

There are only seven days in the week and someday is not one of them.

—Rita Chand

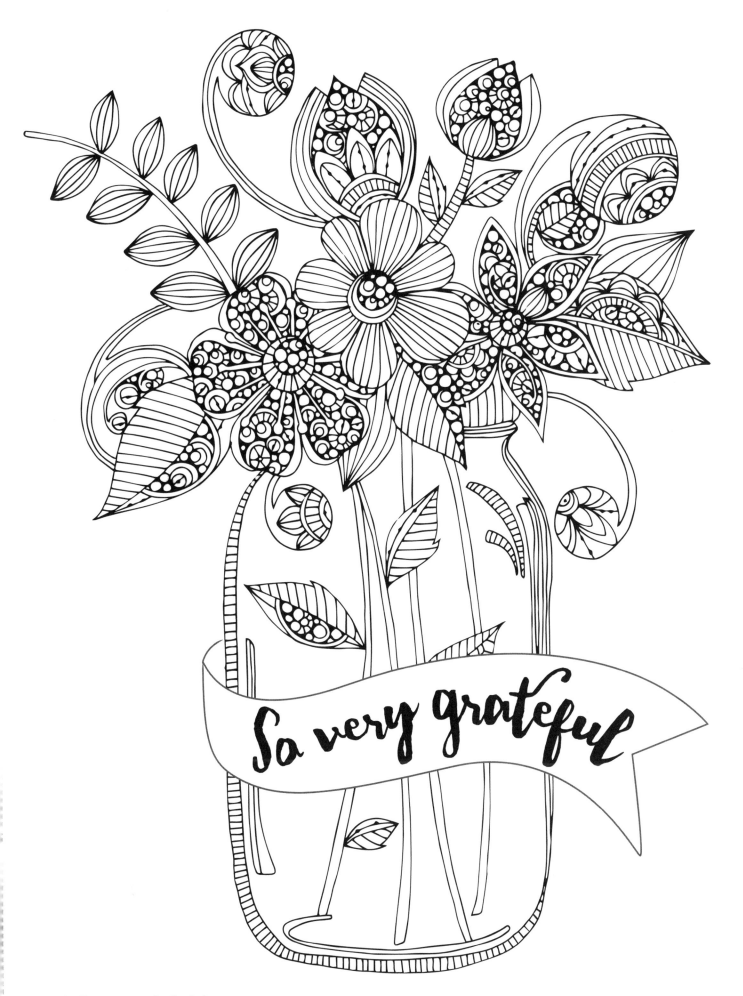

So very grateful

Some people grumble that roses have thorns;
I am grateful that thorns have roses.

—Alphonse Karr, *A Tour Round My Garden*

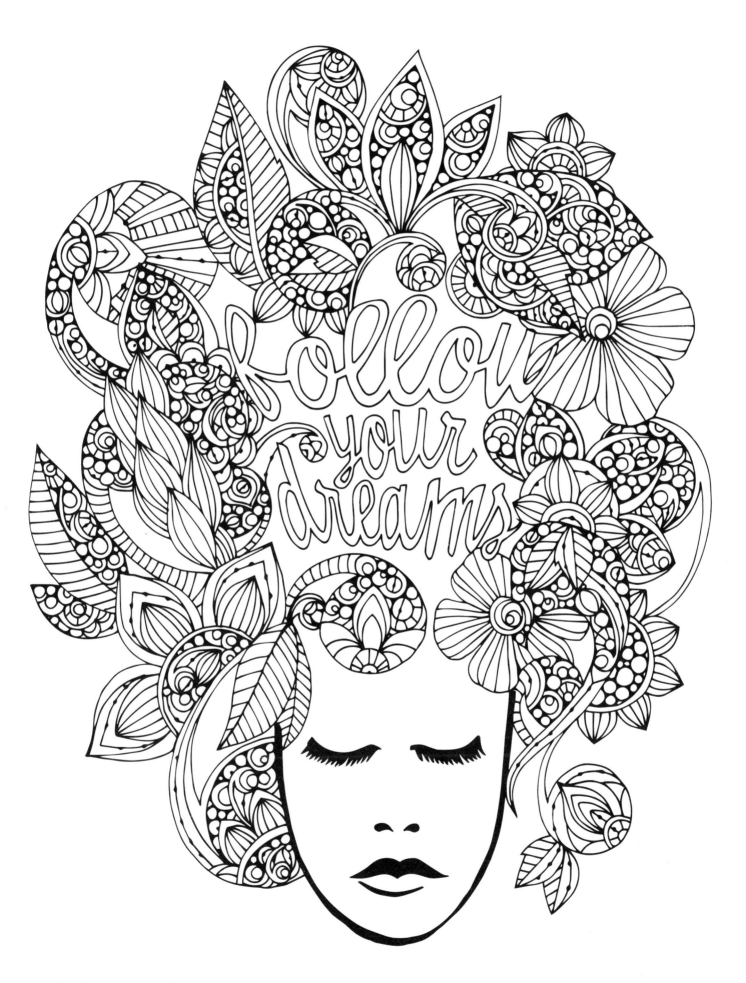

Take what you can from your dreams.
Make them as real as possible.

—Dave Matthews

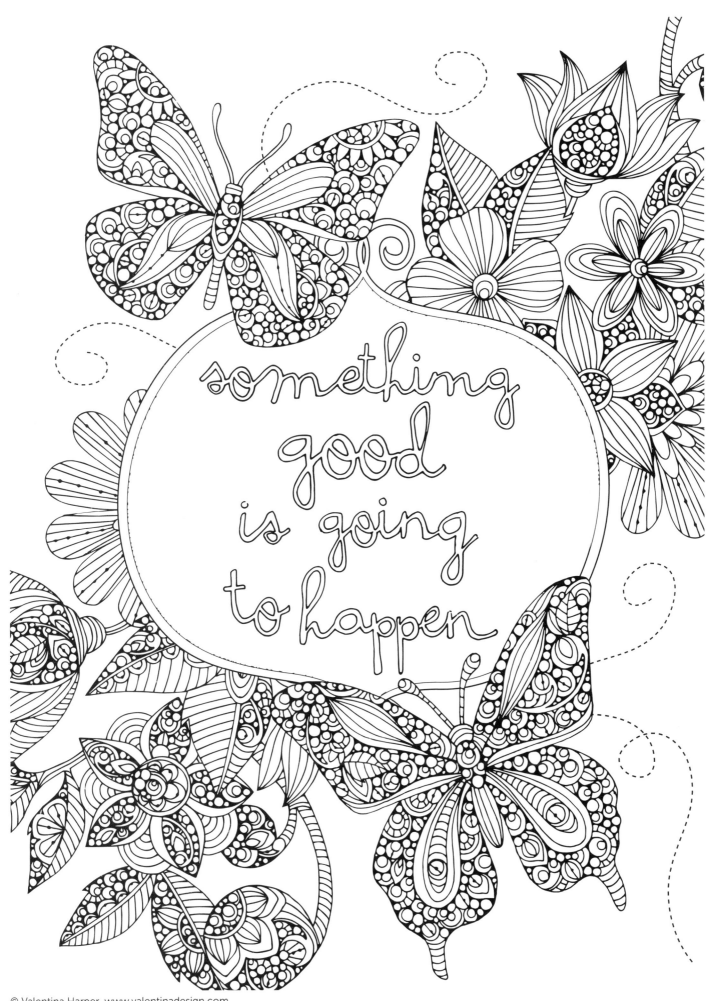

Drench yourself in words unspoken.
Live your life with arms wide open.
Today is where your book begins,
the rest is still unwritten.

—Natasha Bedingfield, *Unwritten*

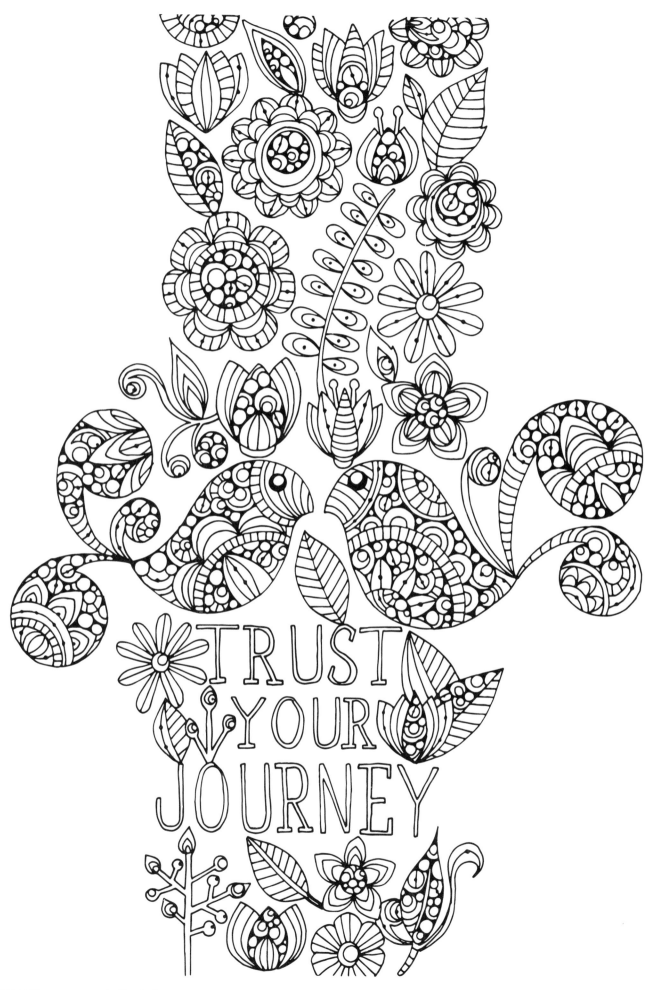

If my ship sails from sight, it doesn't mean
my journey ends. It simply means
the river bends.

—Enoch Powell

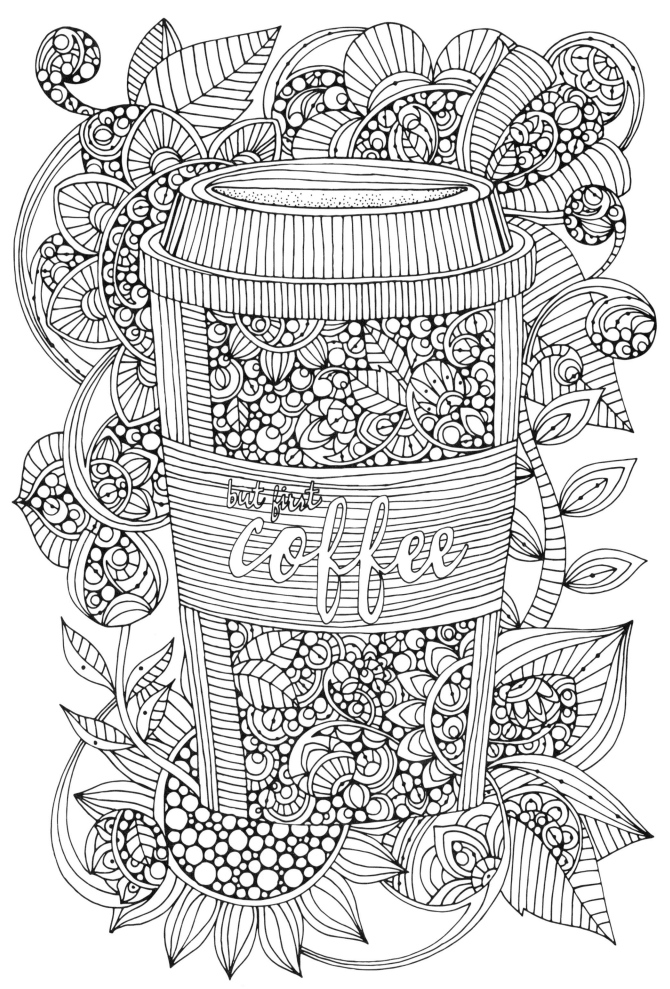

but first coffee

It's amazing how the world begins to change
through the eyes of a cup of coffee.

—Donna A. Favors

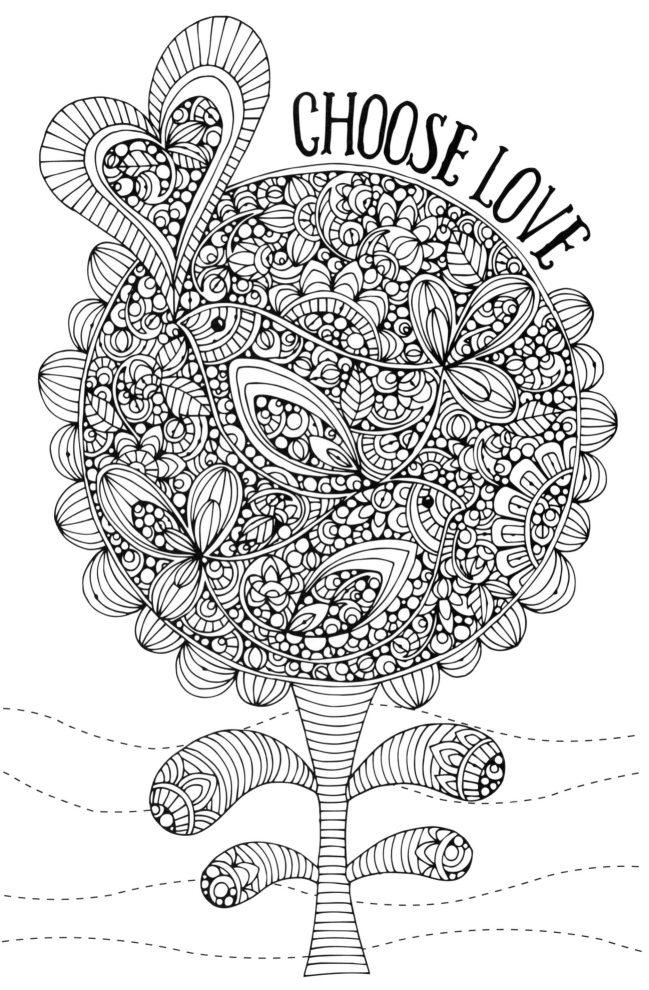

CHOOSE LOVE

I believe that every single event in life
that happens is an opportunity to choose
love over fear.

—Oprah Winfrey

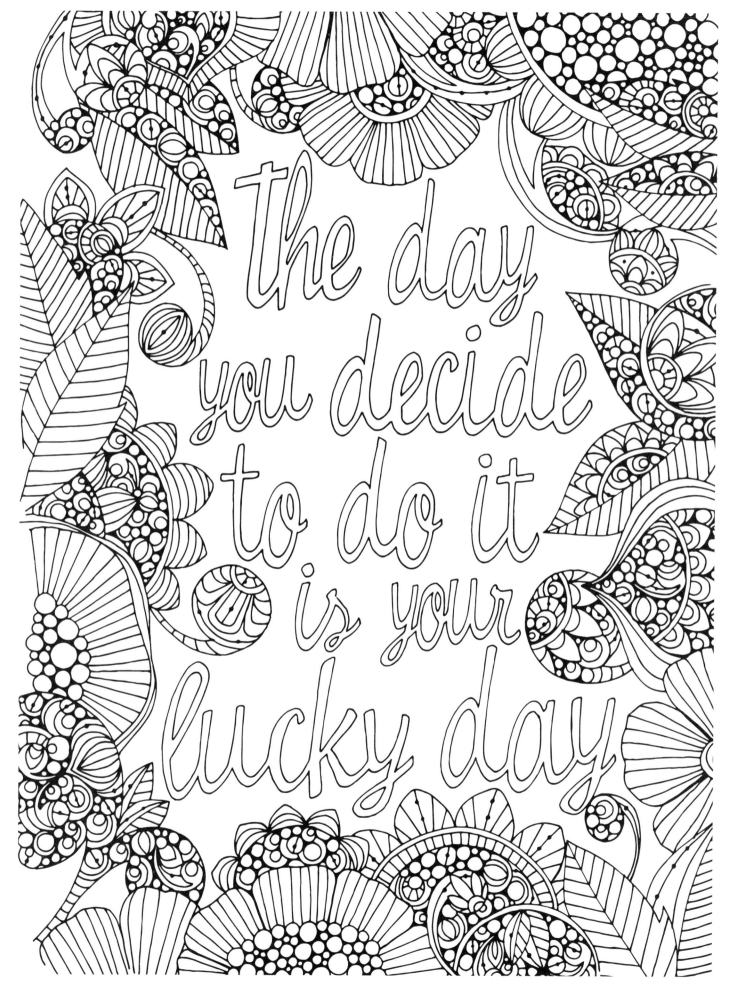

the day you decide to do it is your lucky day

Life always begins with
one step outside your comfort zone.

—Shannon L. Adler

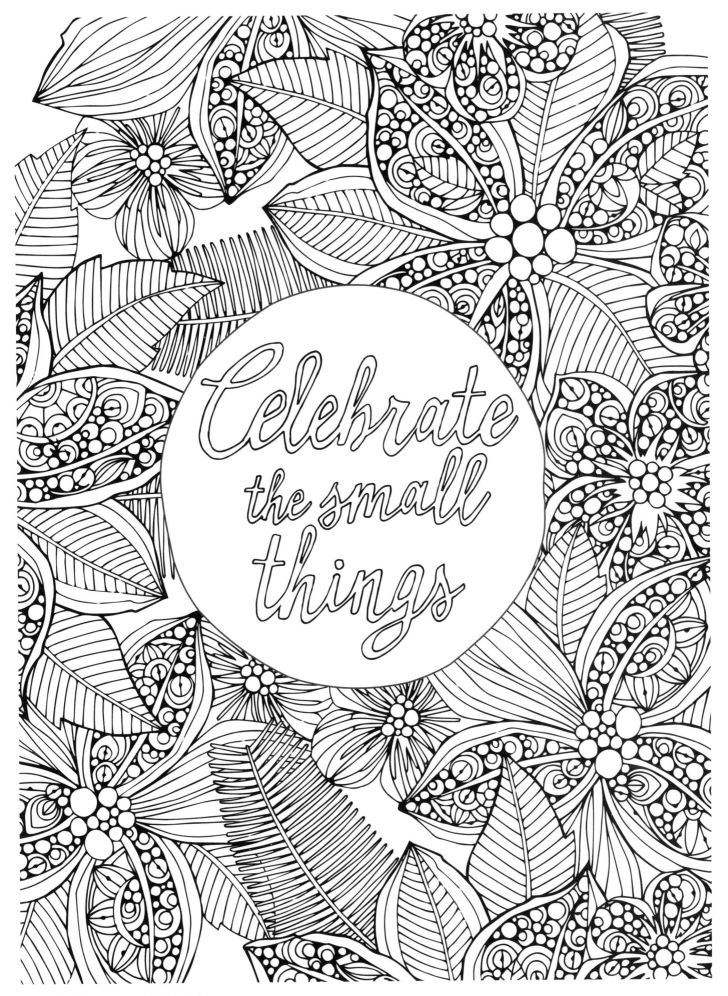

Celebrate the small things

The little things? The little moments?
They aren't little.

—Jon Kabat-Zinn

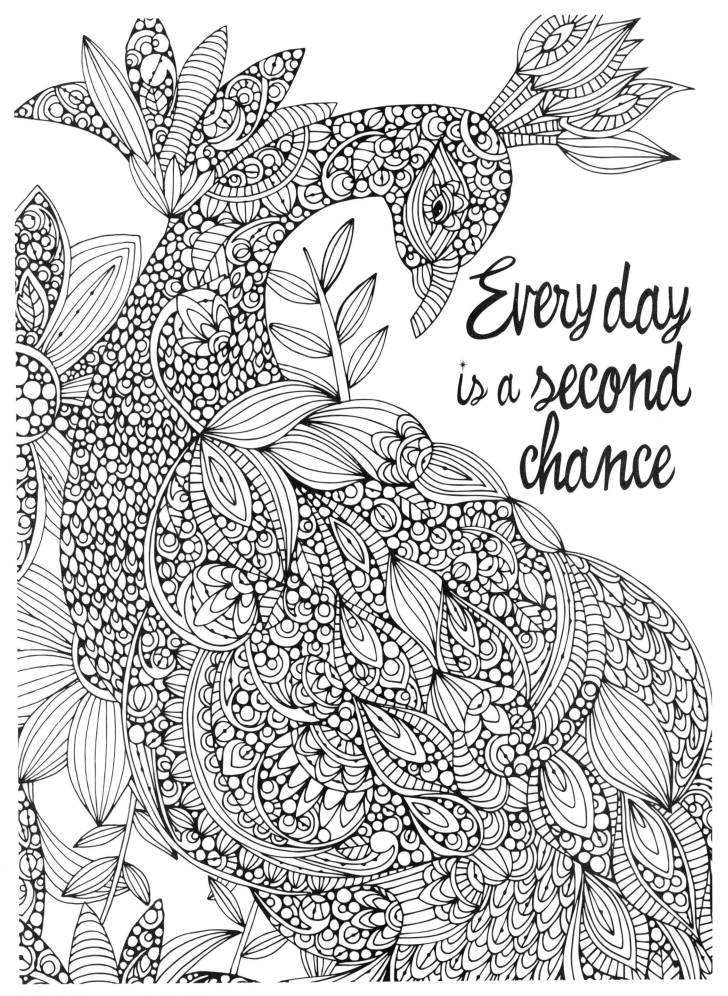

Every day is a second chance

There's another train, there always is.
Maybe the next one is yours.
Get up and climb aboard.

—Pete Morton, *Another Train*

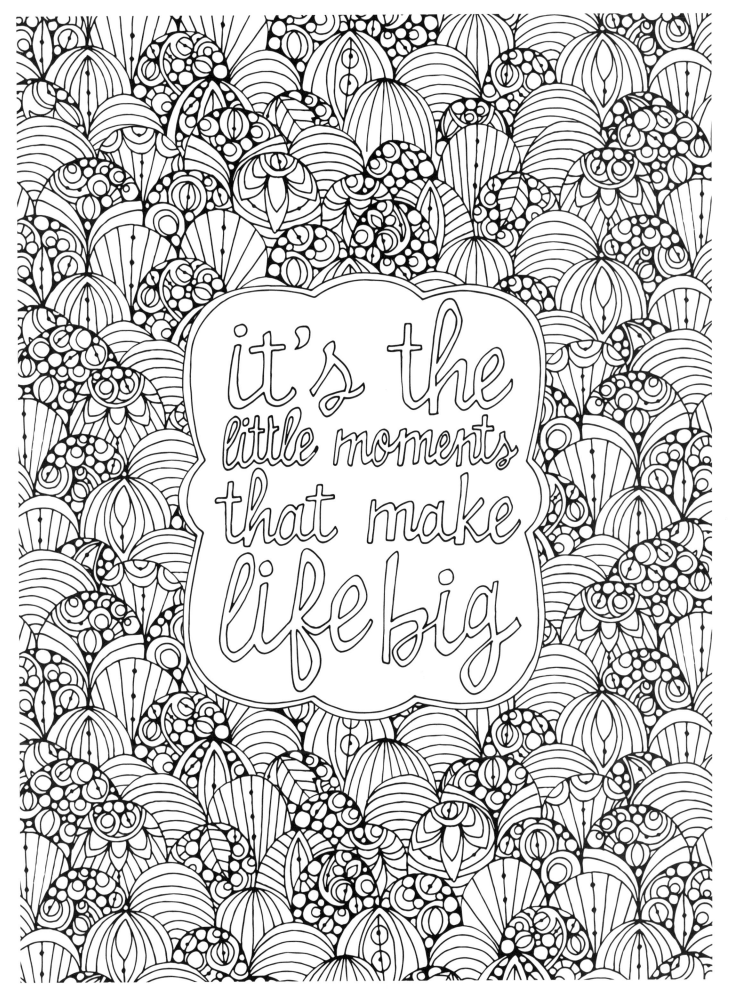

it's the little moments that make life big

Don't wait for the perfect moment,
take the moment and make it perfect.

—Zoey Sayward

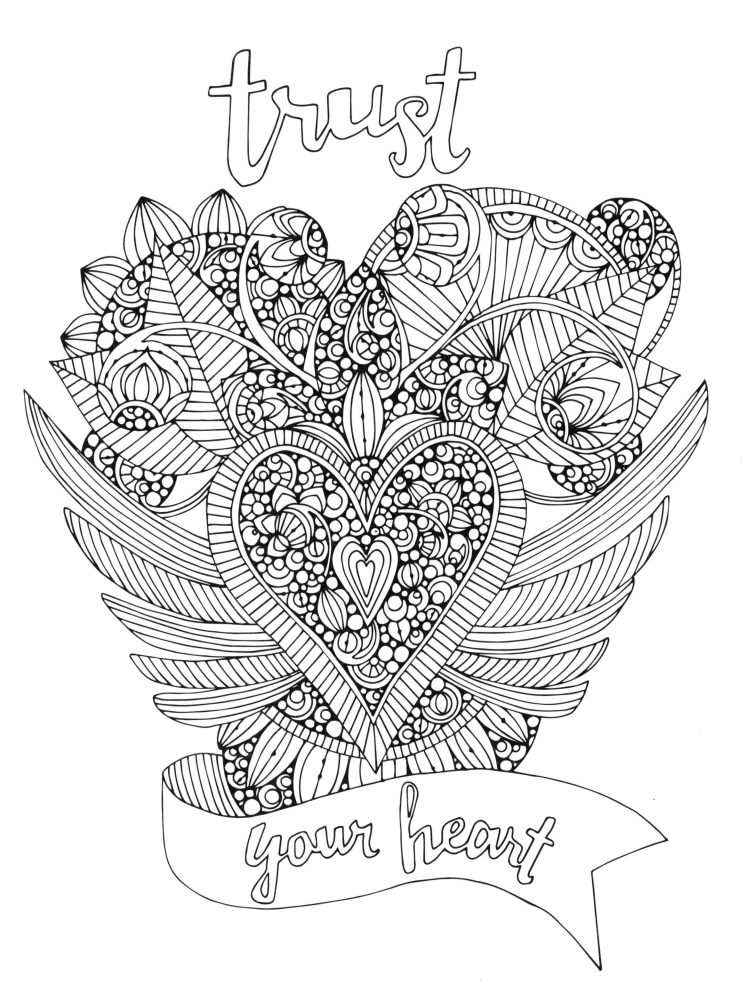

Your heart is free.
Have the courage to follow it.

—*Braveheart*

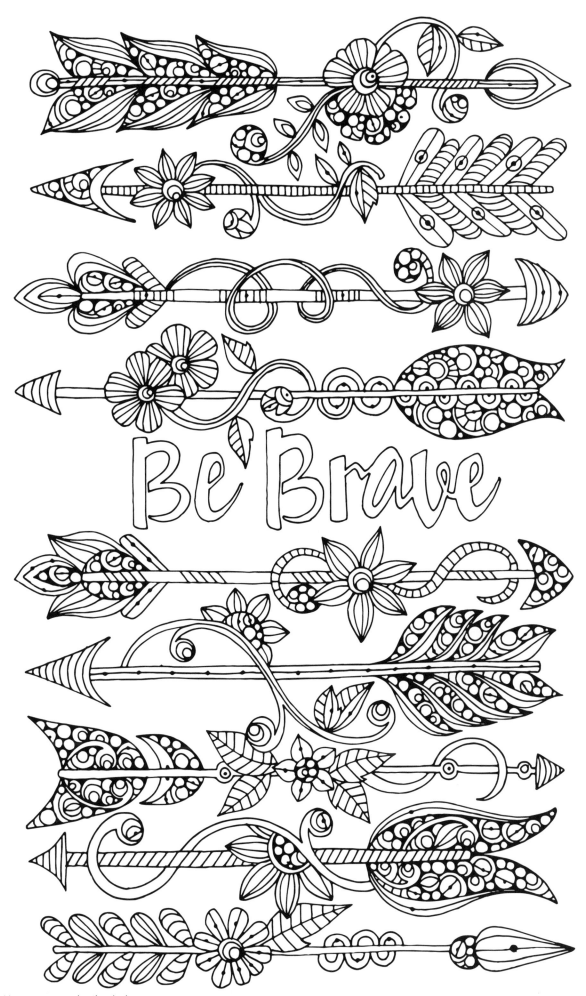

Success is not final, failure is not fatal:
it is the courage to continue that counts.

—Winston Churchill

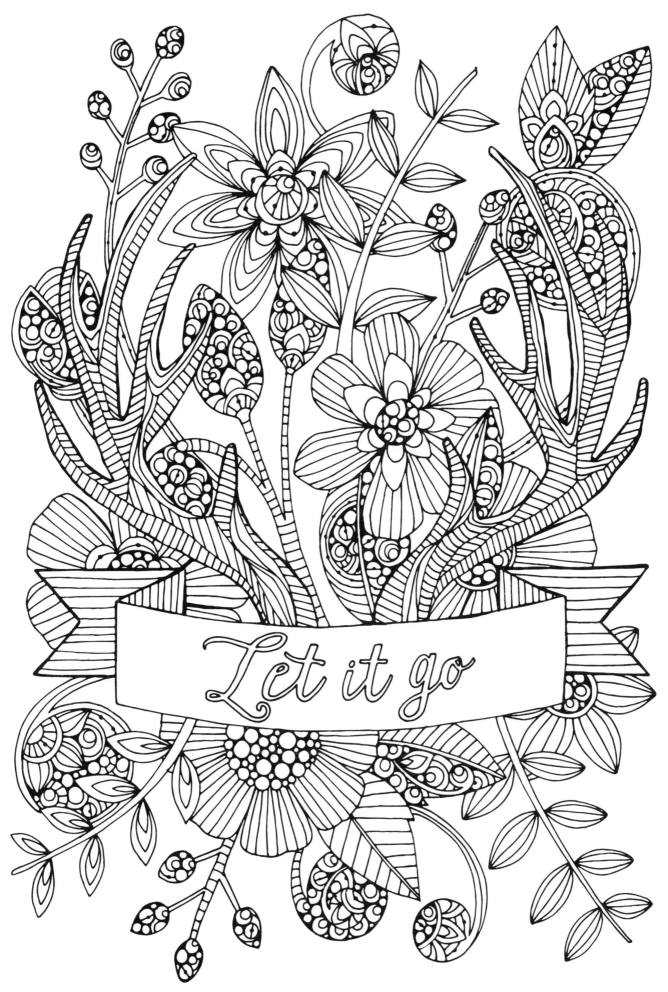

Use memories. Do not let memories use you.

—Deepak Chopra

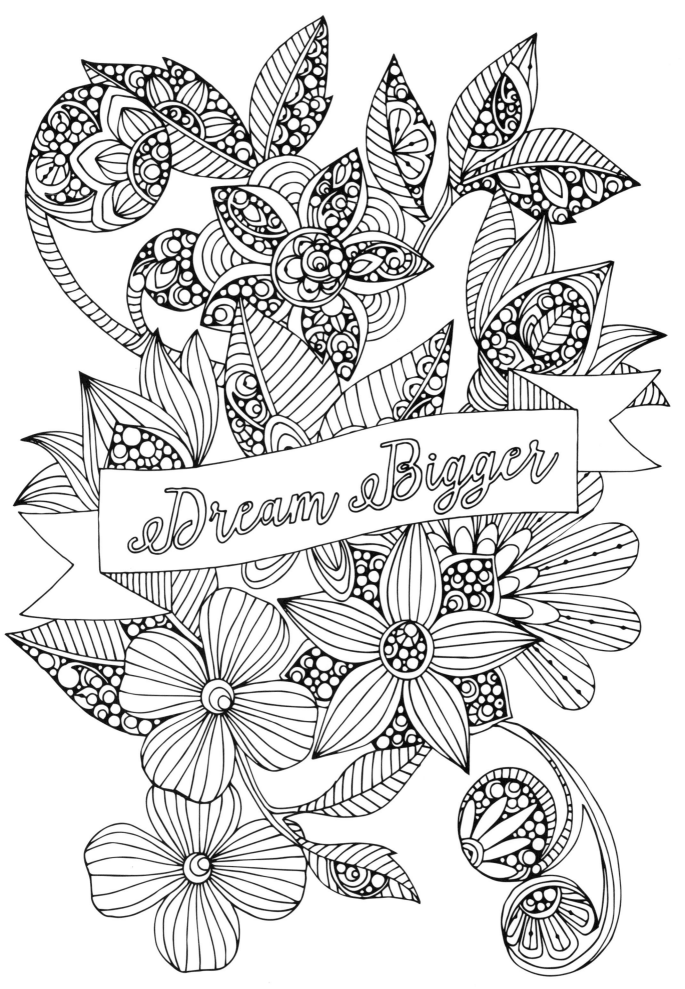

Dream Bigger

Risk more than others think is safe.
Care more than others think is wise.
Dream more than others think is practical.
Expect more than others think is possible.

—Claude Bissell

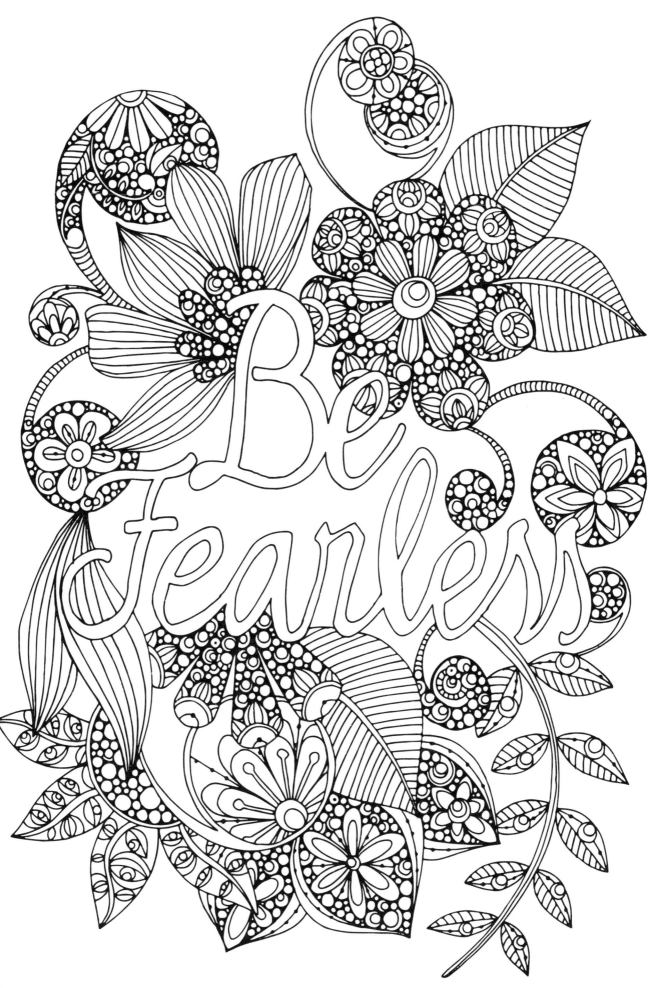

Don't be afraid of your fears.
They're not there to scare you.
They're there to let you know
that something is worth it.

—C. JoyBell C.

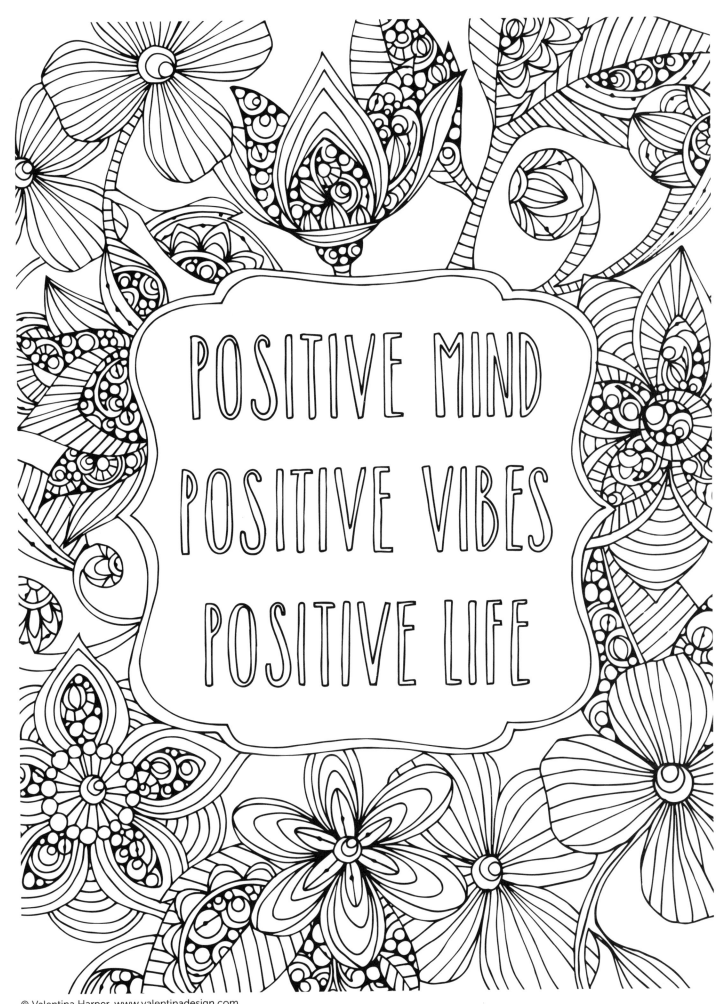

POSITIVE MIND
POSITIVE VIBES
POSITIVE LIFE

Believe in yourself and all that you are.
Know that there is something inside you
that is greater than any obstacle.

—Christian D. Larson

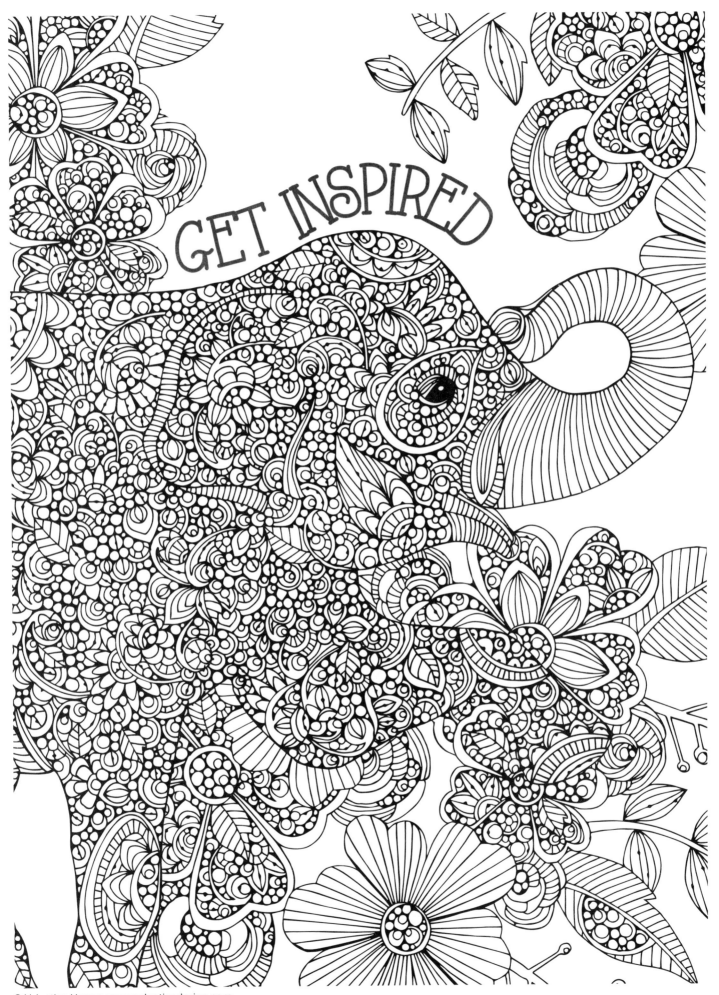

GET INSPIRED

If not me, who? And if not now, when?

—Mikhail Gorbachev

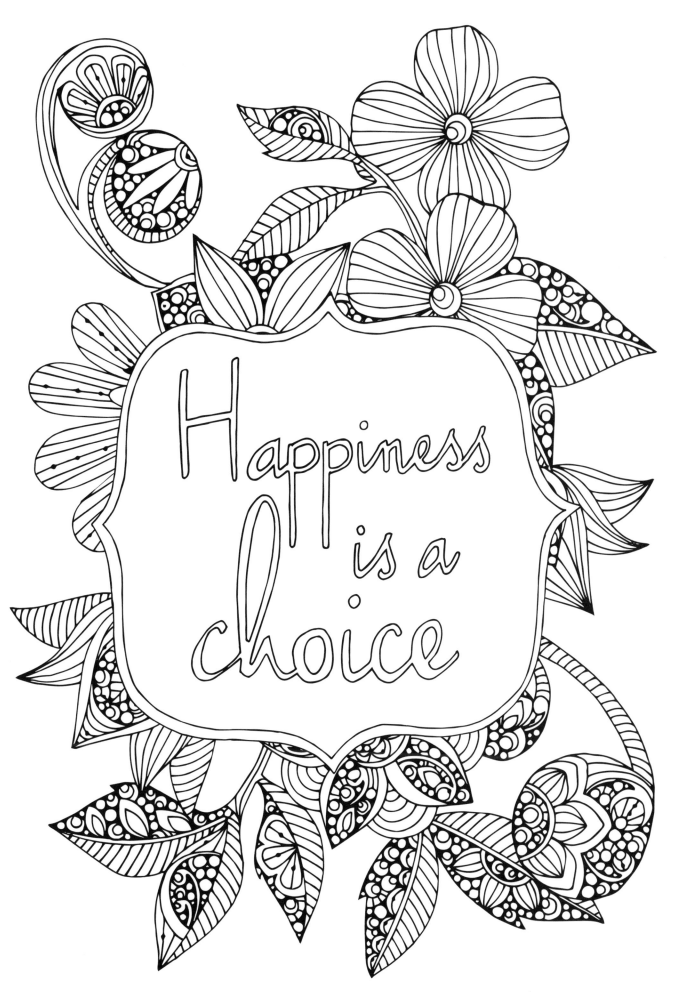

If you want to be happy,
you have to be happy on purpose.
When you wake up, you can't just
wait to see what kind of day you'll have.
You have to decide
what kind of day you'll have.

—Joel Osteen

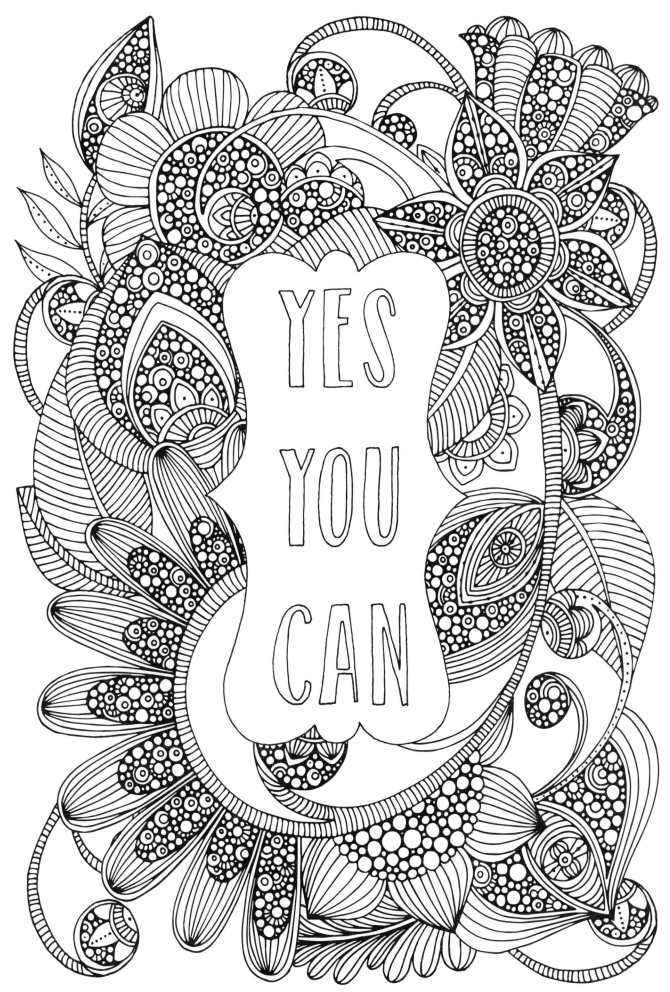

When the water rises
Reach for higher ground
Lose your fear of flying
Leave your doubts up in the clouds.

—Vanessa Amorosi

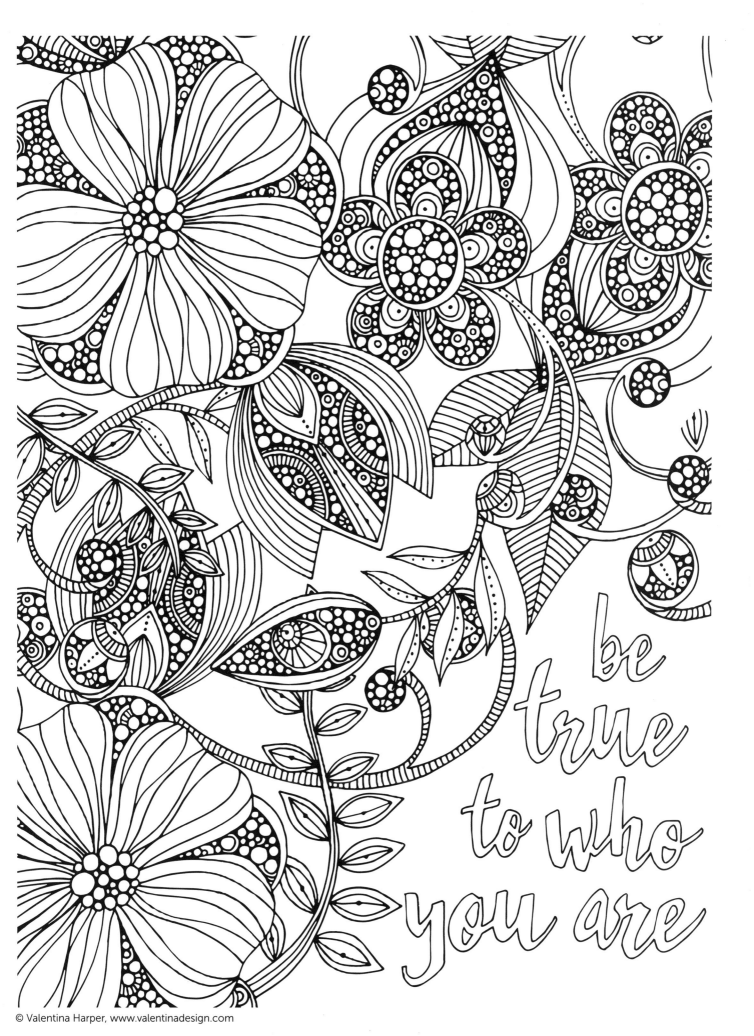

be true to who you are

Above all, be true to yourself,
and if you cannot put your heart in it,
take yourself out of it.

—Hardy D. Jackson